SKETCH YOUR WAY TO AN EVERYDAY ART HABIT

ILLUSTRATED BY **KERBY ROSANES**

TEXT BY LAURA SIMMS

Race Point
PUBLISHING

Quarto is the authority on a wide range of topics.

Quarto educates, entertains and enriches the lives of
our readers—enthusiasts and lovers of hands-on living.

www.quartoknows.com

Illustrations © 2015 Kerby Rosanes
Text © 2015 Laura Simms

First published in the United States of America in 2015 by
Race Point Publishing, a member of
Quarto Publishing Group USA Inc.
142 West 36th Street 4th Floor
New York, New York 10018
Telephone: (978) 282-9590
Fax: (978) 283-2742
quartoknows.com
Visit our blogs at quartoknows.com

10 9 8 7 6 5 4 3

ISBN: 978-1-63106-116-5

Library of Congress Cataloging-in-Publication Data

Graph paper © Shutterstock/The_Pixel

Printed in China

CONTENTS

INTRODUCTION

Welcome to your new drawing habit!

If you're like me, the word "habit" sounds like a drag. I used to think that habits were boring, rigid, and the very antithesis of art. To me, art was about spontaneity and waiting for inspiration to strike.

I have dabbled in many things: painting, songwriting, improv, photography, writing, and, yep, even drawing. What I discovered is that the creative pursuits I gave the most structure and attention to were the ones that became the most enjoyable (and even profitable). My art got better when I treated it a little more seriously. And being good at things is *fun*.

As a career coach, I help people figure out what fulfilling career they should pursue. While that process is not about sketchbooks and art pencils, it is about helping people do more of what makes them come alive. I've seen again and again that it's commitment (even more than upbringing or education) that separates the people who achieve their career goals from the people who just dream about them.

This book will help you make and *keep* (the important part) a renewed commitment to drawing. You'll get a sneak peek into the creative habits of established, prolific artists so you can see how the masters make it work. You'll also learn simple strategies that will keep you coming back to the page—some of which are age-old and some that are supported by the very latest neuroscience.

In fact, science has informed the very structure of this book. A study by health psychology researcher Phillippa Lally out of University College London found that the average time it takes to form a new habit is 66 days, and that's why you'll find 66 sketch pages in this book. Just use one a day, and you'll be well on your way to creating a lasting drawing habit.

From learning how to make time for drawing to handling the emotional aspects of being a creator, you'll learn how to navigate all the challenges that can come up when you decide to get serious about drawing.

Part inspiration, part call to action, part how-to manual, and all sketchbook, *Never Quit Drawing* will help you draw more often, and with more enjoyment and ease. That's the beauty of habits, and you're going to master them with this book.

The artist you want to become is waiting for you in these pages, so get started!

Laura Simms, career coach and creator
of Your Career Homecoming

HOW TO USE THIS BOOK

Master doodler Kerby Rosanes boldly proclaimed in one of his unforgettable sketches to "Never Quit Drawing" and we were inspired. But how do you build the drawing habit? How do you make it a part of your everyday life that is already jam-packed with obligations, work, emails, classes, texts, friends, family, and more? How do you live the creative life and never quit?

In *Never Quit Drawing*, career coach Laura Simms shows you all the simple tools and tricks you need to build a drawing habit and make it a part of your life; whether you want to make art your career or simply a regular hobby that you find rewarding.

People used to theorize that it took 21 days to build a habit. The truth is that the time it takes to build a habit varies from person to person. Some lucky individuals can create a habit or ritual in 21 days. For others, it can take over a hundred. Recent studies (see page iv) indicate that the average time is around 66 days. So in addition to the latest habit-building techniques you'll find throughout this book, we've also included 66 sketch pages (11 pages after every chapter). You can look at *Never Quit Drawing* as your key to an artful existence. Commit to drawing something on each of these pages every day—even if it's the worst drawing you've ever sketched—and you will be well on your way to your drawing habit and maybe the *best* drawing you've ever sketched.

Each sketch page also includes "Mood/Energy Level" and "Time of Day" at the top. When you start your drawing for the day, make a note of the time of day and how you're feeling. This journal/sketchbook approach will help you figure out what time of day and which mood helps you do your best work. Sometimes simply recognizing that you're too tired at night to produce something will help you make the decision to draw in the morning (or vice versa).

MOOD/ENERGY LEVEL: *Energized and excited about an idea.* **TIME OF DAY:** *9:30 am*

And if you need some inspiration along the way, Kerby Rosanes (who quit his day job to pursue his art full time) has doodled his way through the book to help you out. So why wait? Start your drawing habit today. After all, you probably won't look back and wish you had spent more time on Twitter!

A NOTE FROM KERBY ROSANES

I believe that all of us were born as artists. And I bet most of us enjoyed using the mighty pencil and coloring pens at some point during our good old days as kids. The challenge is how to maintain that creative spark as we grow up.

Drawing has been with me since the first time I used crayons when I was five. I always knew I wanted to grow up as creative as I could. It wasn't an easy road. There were tons of frustrations and challenges. I almost gave up with my art when I was in college. I took a different path, found a stable job, but I knew something was lacking within me. Just over a year ago, I quit my day job. I picked up my pens and sketchbooks once more and started living my life with something I truly love. It was the best decision I ever made.

It is never too late to pick up your pencils again, whether you're serious and want to make a career out of it or just as a fun hobby and a source of personal happiness. This book is a great starting point. Let's begin your drawing habit today!

Kerby

CHAPTER ONE

HACK THE HABIT

START A HABIT

Think of an artist you admire, or perhaps are even a little envious of. Perhaps he has more skill or experience than you, which are things you can develop over time. There is something else he may possess that every great artist needs, and it's something that you can start right now. That thing is a habit—a drawing habit.

Your parents or teachers may have nagged you about habits in a way that caused you to have a negative association with them, or at the very least made "habit" into a dirty word associated with boredom and drudgery. But habits don't exist because they are a morally superior way of working; creating a habit is the most effective and easiest way to work—and for you to draw on a regular basis. If you want to be a prolific artist, why not take the fastest route to get there.

Aristotle made the case for habits over two thousand years ago when he wrote that "virtues are formed in man by his doing the actions." In his book *The Story of Philosophy*, historian Will Durant popularizes this notion with a spiffier interpretation: "We are what we repeatedly do. Excellence then, is not an act, but a habit."

While the importance of habits may be ancient wisdom, modern science confirms it. Neuroscience suggests that our brains process habitual tasks in a different way than nonhabitual tasks. Activities that are not habits take willpower, and using willpower takes work.

DON'T MOVE A MUSCLE

Think of willpower as a muscle; it takes energy and effort to move the muscle, and the muscle can be worked to exhaustion. Once it's worn out, it needs recovery time to repair before it can do more work. So, your willpower has limits and can be used up. If you're using willpower to complete other tasks in your life, like going to the gym, doing homework, or even picking out what you're going to wear in the morning, you may not have any willpower left when it comes to drawing.

Our brains treat habits differently. Once a habit is built, it's an automated process. It's like the difference between collecting, roasting, and grinding your own coffee beans for a

cup of coffee, and pressing the button on a coffeemaker that uses single-serve pods. When it comes to drawing, why not press the button?

Researchers have discovered that all habits operate in a three-step loop, and that you can consciously create new habits by making simple adjustments. Charles Duhigg, author of *The Power of Habit*, breaks down the three steps in this way:

First, there is a cue, a trigger that tells your brain to go into automatic mode and which habit to use. Then there is the routine, which can be physical or mental or emotional. Finally, there is a reward, which helps your brain figure out if this particular loop is worth remembering for the future.

As your brain adjusts, this three-step loop becomes more automatic over time.

Here's how you can take advantage of the hardwired processes of your brain to hack a drawing habit. First, you need a cue that will set off a chain reaction in your brain that says, "Oh, I'm going to draw now." The cue itself is not as important as the consistency with which it occurs in your day. Think about an event that happens almost without fail in your daily schedule, like waking up, taking a lunch break, or getting home from work or school. Use one of those events as a trigger, and commit to drawing every time that event takes place.

The cue (waking up) will trigger the routine (drawing), which will stimulate a reward (feeling proud of your work, relaxing, enjoying the time spent drawing, etc.). Take a moment now to consider some possible cues that might work for you, and choose one to try this week.

CREATE YOUR OWN RITUAL

Another way to think about creating a habit is in terms of ritual. Sometimes seen as having quirky or superstitious behavior, artists who employ rituals—an idea we've connected with for centuries—are doing exactly what research tells us is effective for habit formation: relying on a behavior chain.

The legendary Maya Angelou didn't feel she could write at home, so she rented a no-frills hotel room where she could do her writing each morning. Academy Award–winning

screenwriter Aaron Sorkin admits to taking up to six showers a day, using each one as a fresh start when he's stumped on a project. In her book *The Creative Habit*, dancer and esteemed choreographer Twyla Tharp tells the story of her exercise habit: hailing the cab to get to the gym is the ritual, and once she's there, she can do whatever she wants.

Create a ritual where showing up to the page is the goal; once you're there, you can do whatever you want, and stay for as long as you want. Research out of Stanford University suggests that making a broad resolution like, "I'm going to draw more," is practically doomed, but committing to a more specialized habit like, "I'm going to draw every time I ride the subway," is much more likely to lead to success.

If you want to draw often, don't wait for inspiration, and don't rely on willpower. Make showing up to the page a habit; it's simply the easiest way to never quit drawing.

DAY 1

MOOD/ENERGY LEVEL: TIME OF DAY:

DAY 2

MOOD/ENERGY LEVEL: TIME OF DAY:

DAY 3

MOOD/ENERGY LEVEL: TIME OF DAY:

DAY 4

MOOD/ENERGY LEVEL: TIME OF DAY:

DAY 5

MOOD/ENERGY LEVEL: _____ TIME OF DAY: _____

DAY 6

MOOD/ENERGY LEVEL: TIME OF DAY:

DAY 7

MOOD/ENERGY LEVEL: TIME OF DAY:

DAY 8

MOOD/ENERGY LEVEL: TIME OF DAY:

DAY 9

MOOD/ENERGY LEVEL: TIME OF DAY:

DAY 10

MOOD/ENERGY LEVEL:

TIME OF DAY:

DAY 11

MOOD/ENERGY LEVEL: TIME OF DAY:

CHAPTER TWO

FINDING TIME

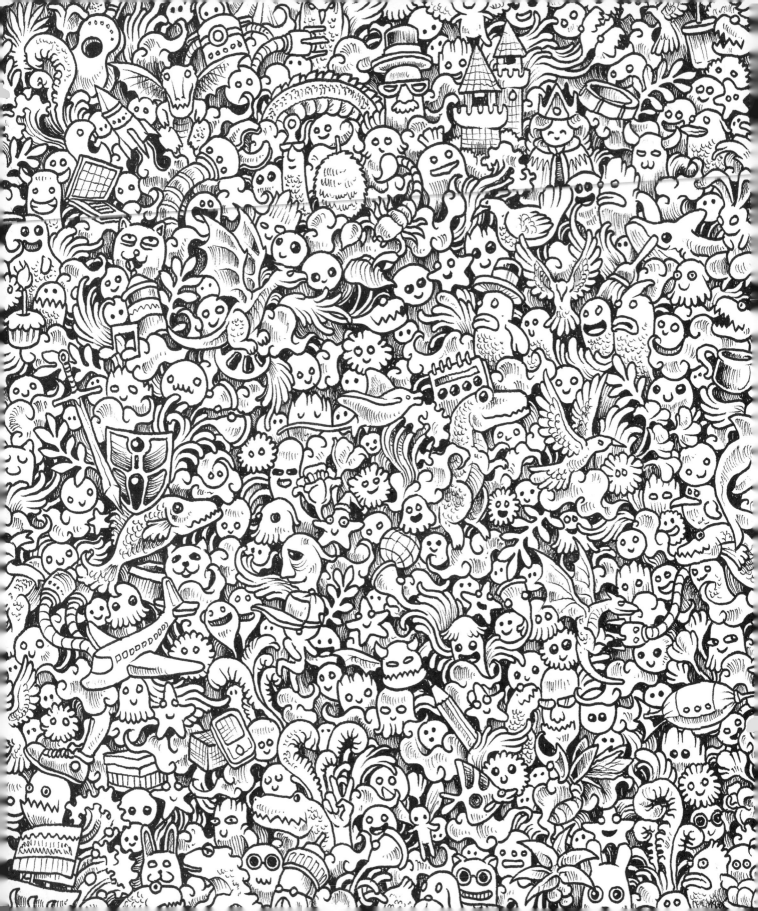

MAKE THE MOST OF YOUR MINUTES

Now that you've started hacking your drawing habit, you may be finding that you don't have as much time as you'd like for drawing. Here's some good news: you probably do have the time, or at least more than you think you do.

Do you ever think, "Well, I can't draw now, because I don't have an hour (or half-hour, or twenty minutes)"? We tend to conceptualize time in tidy chunks, and when a tidy chunk isn't available, we dismiss it. If you don't have an hour, draw for seventeen minutes, or for four minutes. Four minutes may not sound like a lot of time, but it is four more minutes you have spent drawing. Those little pockets of time add up; you don't have to wait for tidy chunks to draw.

In fact, you probably have lots of little pockets of time throughout the day that you could make use of. Of course, it's ideal to have dedicated drawing time in your schedule, but take advantage of the stolen moments—use the "nooks and crannies" in your day: time you haven't specifically set aside for drawing, but that occurs anyway.

DRAW IN THE MOMENT

So how do you take advantage of these moments? Always carry a sketchbook with you. Then, anytime you have to sit around and wait (and let's be honest, you would probably pull out your mobile phone), use that time to draw. During your commute, waiting for the oven to preheat, before your dentist appointment—reclaim that time and use it for your art.

It's not just that these small moments add up, but there's biological power behind "just getting started." The Zeigarnik Effect states that the mind wants to complete tasks that are unfinished. When tasks are left undone, we have intrusive thoughts about them and an urge for closure around them. This means that if you start a drawing during some scrap of time, your brain is wired to return to it and complete it.

31

JUST SAY "NO"

If you're still unable to find enough time in your day, you may have to make some time. In his book, *How to Fly a Horse*, author Kevin Ashton writes that "creative people say no." This essentially means that people with big creative output turn down lots of invitations and requests. It's not that they're rude, but that they're dedicated to their work. If you're aching for more time to draw, start saying "no" to things; you'll be amazed at how much more time you have for drawing once you put it first.

You may want to say "no" to yourself too. Most of us have several passive activities that we participate in on a daily basis, including reading, watching television, being on social media, and playing video games. Even if you're mentally engaged while playing a video game or doing a puzzle, your role is as a participant, not a creator. You get to enjoy an experience that someone or something has facilitated, but you aren't creating anything. It's okay to have downtime, and time to play and recuperate, but you could probably get away with swapping some of that time for more creative activities, such as drawing.

Try taking a weeklong vacation from one passive activity. For example, if you normally watch one episode of your favorite sitcom after dinner, don't watch it this week. Magic! You just found a half-hour you can use for drawing. Or, if you don't feel like drawing after dinner, use that time to get other tasks done so you can free up the time of day when you prefer to draw. You don't need to give up your favorite show forever, just try it for a week, and see if swapping the time for drawing feels like a good trade.

Now that you have several strategies to use, find, create, and swap time spent making art—all of which will help you get more drawing done—there's something else you'll want to take into consideration when finding time to draw, something that you can use to defy and seemingly expand time: your energy level. If you've ever come home after a long day with good intentions of doing something productive, but wound up in front of the television instead, then you've experienced the time-energy conundrum—you technically have the time to get things done, but you don't have the mental energy to do anything but power down.

If you are able to draw when you have the most energy, then you might actually need less time to do the same amount of work. As a writer, I frequently time how long it takes me to complete projects. I discovered that a recurring writing task takes me a half-hour when I work on it in the evening, but only seven minutes when I do a similar task in the morning.

By doing my creative work in the morning, when I'm fresh and have the most mental energy, I stand to complete projects in a quarter of the amount of time that it would take me to do the same work in the evening.

TAKE ADVANTAGE

When you draw, start keeping track of when you feel the most energized and productive. Is it in the mornings, like me? Or maybe after a nap? Or heck, even after a cup of coffee? The goal is to develop awareness around your natural tendencies so that you can take advantage of them. Once you've identified the circumstances when you have the most energy for drawing, protect them. Guard that time and keep it for your drawing, knowing that you might actually be freeing up time elsewhere for other activities.

Where will you find the time to draw? Wherever you can. Steal it, make it, swap it, and take advantage of it.

DAY 1

MOOD/ENERGY LEVEL: TIME OF DAY:

DAY 2

MOOD/ENERGY LEVEL: TIME OF DAY:

DAY 3

MOOD/ENERGY LEVEL: TIME OF DAY:

DAY 4

MOOD/ENERGY LEVEL: TIME OF DAY:

DAY 5

MOOD/ENERGY LEVEL: TIME OF DAY:

DAY 6

MOOD/ENERGY LEVEL: TIME OF DAY:

DAY 7

MOOD/ENERGY LEVEL:

TIME OF DAY:

DAY 8

MOOD/ENERGY LEVEL: TIME OF DAY:

DAY 9

MOOD/ENERGY LEVEL:

TIME OF DAY:

DAY 10

MOOD/ENERGY LEVEL: **TIME OF DAY:**

DAY 11

MOOD/ENERGY LEVEL:

TIME OF DAY:

CHAPTER THREE

BE AWESOME TODAY

You bought this book! You're excited to draw! This is going to be awesome! You'll start drawing tomorrow...

Womp, womp. You just fell into a classic procrastination trap. It's the same trap that has people buying gym memberships on New Year's Day and starting that diet on Monday. "Tomorrow" may sound like the perfect day to begin something new, but why not be awesome *today*?

CONQUER PROCRASTINATION

Piers Steel, a leading expert on procrastination and the author of *The Procrastination Equation*, defines this very human tendency as "willingly deferring something even though you expect the delay to make you worse off."

Sounds completely irrational, right? So why do we do it? And how can we stop?

The act of procrastinating may be perceived as laziness (a character flaw) or as a form of fear (buck up!), but Steel's research concludes that it's neither of these things. The reason you're putting off drawing, he says, is because your motivation "equation" is poorly balanced. If you want stronger motivation, you need to increase the value you receive from drawing, and decrease the impulsiveness that takes you away from it.

With Steel's equation in mind, there are ways to manage your mojo. But first, let's talk about why addressing procrastination is so important. Obviously, the more procrastinating you do, the less drawing you do. Steele says that there's a higher cost to procrastinating: When you procrastinate, not only do you miss out on the rewards of the task you're putting off, but you also rob yourself of the pleasure that comes with a well-earned rest. When you delay taking action on something, you may have nagging thoughts about it and experience anxiety that spills into the rest of your life. Drawing is supposed to make your life better, but when you put it off, it can actually negatively impact you.

So how can you prevent this from happening? The goal is not to eliminate procrastination (we all do it), but rather to minimize it so that you will draw more often and feel better. Win, win!

GET MINDFUL ABOUT IT

Going back to Steel's equation, let's start with increasing the value you receive from drawing. Think about it: why do you draw?

There may be some immediate rewards you get from drawing. Maybe drawing is meditative for you, or you feel proud of your work once it's done, or you love the challenge of drawing something now. Are there any bigger rewards that are perhaps a little farther removed? What are the potential outcomes if you keep drawing? You'll get a lot of followers on social media? Get hired by your favorite design studio? Have a body of work large enough and prestigious enough for a gallery show? Get a book published? Reconnecting to why you draw—both the immediate reasons and the far-off ones—can help keep you from procrastinating.

But don't daydream about that gallery show too much. Of course, visualization can help you achieve your goals, but it's better to envision the process it will take to get there instead of the results. A study from UCLA found that when students preparing for midterms visualized the process required to attain a good grade (studying), they actually performed better than students who visualized the outcome (getting a good grade).

Take a moment now to practice this flipped perspective and visualize your drawing process. Where are you drawing? How are you feeling? What materials are present? What can you hear? How is the lighting? Is it warm or cold? Try visualizing using an outsider's perspective, as if you're watching a movie of yourself. By simply engaging your imagination in this way, you increase your chances of drawing more often. What a fascinating and powerful thing!

TREAT YOURSELF

Another way to increase the value of your drawing time is by finding ways to make it more rewarding. Kerby Rosanes, the master of doodles himself, sometimes uses this method. Instead of sitting down to draw for an hour, he will read a comic for fifteen minutes, play a video game for fifteen minutes, draw for thirty minutes, and then repeat the cycle. To some, this pattern of activity could look like Kerby's wasting a perfectly good half-hour on

comics and games that he could instead put toward his drawing. But because he's made drawing even more rewarding, that time he spends "playing" could be the thing that keeps him drawing. Besides, isn't it nice to think that drawing is "playing" too?

Now that you have some ideas about increasing the value you receive from drawing, it's time to tackle the other part of Steel's procrastination equation: impulsiveness. Basically, you want to be less impulsive, which sounds, well, boring. Though it might not be the most exciting part of your relationship with drawing, stunting impulsiveness can be an extremely effective tactic. You may also find that if you can be more structured and predictable in this area of your life, you'll have more room for fluidity and spontaneity in other areas. For example, with your drawing time squared away, you could meet up with friends at the last minute without guilt or anxiety because you know that your drawing won't take a hit.

DRAW NAKED

The first order of business is to reduce distractions. Most of us have a computer or tablet on our desks and a smartphone in our pockets that act as amazing portals to any information we could ever hope for, as well as instant access to friends, cat videos, celebrity gossip, twenty ways to cook chicken tonight, etc. If we let it, the Internet will eat our time—and our attention—alive.

When it comes to staying out of the rabbit hole of social media and the Internet, do what you need to do. Block your access to the Internet with an app like Self-Control (Mac) or Freedom (PC), remove social media apps from your phone, or even leave the phone at home and go draw outside. Don't trust your willpower to be a safeguard—we already know how unreliable willpower can be (see page 3)—and set up external buffers instead. Victor Hugo, author of *Les Misérables*, is reported to have reduced his distractions by locking away his formal "going out" clothes and writing naked, save for wearing what was essentially a wearable blanket. Do what it takes!

60

KEEP IT SMALL

Another way you might curb impulsiveness is by making your task smaller. Let's say you're drawing a large portrait. It might be easier to dive in and get drawing if you focus on completing only one aspect of the picture. So instead of telling yourself that you have to work on the entire picture, you could tell yourself that you're just going to work on the background, or the nose. Because small goals are easier to complete, you'll get a more immediate reward from accomplishing them and that success can snowball, encouraging you to draw more.

Perhaps the most tried-and-true strategy for keeping impulsiveness corralled is having a deadline. For some, nothing inspires action like a good deadline, especially one that other people know about. If you try setting a deadline for yourself, to provide a little healthy pressure to get things done, make yourself accountable to someone else by sharing your deadline with them. You just might find that semi-public deadlines are all you really need to become a more prolific artist.

You *want* to draw, and when you practice managing procrastination, you're learning to honor that want. Remember—

You bought this book! You're excited to draw! Don't wait until tomorrow. Be awesome today!

DAY 1

MOOD/ENERGY LEVEL: _____ TIME OF DAY: _____

DAY 2

MOOD/ENERGY LEVEL: TIME OF DAY:

DAY 3

MOOD/ENERGY LEVEL: TIME OF DAY:

DAY 4

MOOD/ENERGY LEVEL: TIME OF DAY:

DAY 5

MOOD/ENERGY LEVEL: TIME OF DAY:

DAY 6

MOOD/ENERGY LEVEL: TIME OF DAY:

DAY 7

MOOD/ENERGY LEVEL: TIME OF DAY:

DAY 8

MOOD/ENERGY LEVEL: TIME OF DAY:

DAY 9

MOOD/ENERGY LEVEL: TIME OF DAY:

DAY 10

MOOD/ENERGY LEVEL: TIME OF DAY:

DAY 11

MOOD/ENERGY LEVEL: TIME OF DAY:

CHAPTER FOUR

RUIN THE PAGE

You open your sketchbook, and there it is, staring you right in the face:

THE BLANK PAGE.

There's so much potential in that page. You could create *anything*. This could be the page that holds your best work. This could be the page that proves that you really *are* talented—that you aren't a fraud, or wasting your time. This page could confound the people who have doubted that you're good at this. This page could be all of that.

Or it could be the exact opposite of all that.

Yep, one blank page can yield that much power. It's no wonder, then, that marking up the page can be intimidating. Fear of the page doesn't stop at the page. It's not that you're truly afraid of making a not-so-great drawing; you're afraid of what making a not-so-great drawing says about you, to yourself, and to others. When you start to draw, you're not just transferring ink from pen to paper; you're taking on self-worth, criticism, and your very identity as an artist.

Does that sound dramatic? The sneaky part is that fear of the page often masquerades as something else. Something that's easier to claim ownership of and talk about at parties. Not wanting to do bad work—who could fault you for that? You have high standards. You value excellence. The most convenient and socially acceptable label available is "perfectionist."

You can even wear perfectionism as a badge of pride. It can appear synonymous with attention to detail, devotion, and discipline. Elizabeth Gilbert, author of *Eat, Pray, Love*, cuts to the quick on this one. She says, "Perfectionism is just fear in really good shoes."

DON'T FEAR THE BLANK PAGE

Researcher Brené Brown has been studying vulnerability, shame, and courage for over a decade and has written on these topics in two *New York Times* best-selling books. When Oprah Winfrey asked Brown about perfectionism on her *Super Soul Sunday* show, here's what she had to say:

> What emerged for me in the data is that perfectionism is not about striving for excellence or healthy striving. It's...a way of thinking and feeling that says this: "If I look perfect, do it perfect, work perfect, and live perfect, I can avoid or minimize shame, blame, and judgment." I call perfectionism "the twenty-ton shield."

We carry it around thinking it's going to protect us from being hurt. But it protects us from being seen.

According to the data, fear of the blank page is actually the fear of being seen. When you think about drawing, you can idealize what you might draw, and by extension, who you are. Once it's on the page, it's there for you and others to see. Now any judgments made are based on your actual work. The stakes feel high, the potential pain threatening, and the risk great.

BE BAD

How, then, will you ever make that first mark on the page? How can you let yourself be seen, even if you're the only one who will see your drawings?

Well, you can start by committing to making bad art.

Creativity coach and author Eric Maisel is no stranger to working with artists who fear the blank page (and there is an equivalent in every discipline). He says that you can't be afraid to ruin the page.

Can you get on board with ruining the page? Doing mediocre work? Making not-so-great drawings? If so, then you stand a chance at becoming an exceptional artist.

Julia Cameron, prolific author and creator of *The Artist's Way*, argues that it's "impossible to get better and look good at the same time." Artists must not demand perfection of themselves; they must be allowed to fail, to be a beginner, and to royally screw up the art they are creating. Cameron believes that the path to becoming a great artist starts with being a bad artist. It's the artists who are willing to fail that keep going, learning, and continuing on to greatness.

Think about it: you don't often see the early work of artists you admire. Because it was bad! You see their work after they've had time to refine it. J.K. Rowling must have some terrible drafts of *Harry Potter* lying around somewhere, Lady Gaga had to have left a lot of lyrics on the cutting room floor, and Banksy could probably fill a dumpster with designs that didn't work out.

American public radio host and producer Ira Glass learned this the hard way. In an interview that went viral, he said he wished someone had told him that as a beginner, his

work wouldn't live up to his expectations, and that the antidote was to keep working. In his own words, "All of us who do creative work, we get into it because we have good taste. But there is this gap. For the first couple years you make stuff, it's just not that good. It's trying to be good, it has potential, but it's not It is only by going through a volume of work that you will close that gap, and your work will be as good as your ambitions."

And writer Anne LaMott in *Bird by Bird*, her popular book about writing, says, "Almost all good writing begins with terrible first efforts. You need to start somewhere. Start by getting something—anything—down on paper."

When you ruin the page, you join the pantheon of the greats. And if you keep going, your work will have the opportunity to flourish.

FEEL GOOD ABOUT BEING BAD

In the meantime, drawing something that didn't turn out the way you had hoped may sting. Nobody likes the feeling of having done something poorly. But it's important to manage negative thoughts about yourself and your work. Here are five steps you can take to process the emotional side effects of creating what you view as not-so-great art:

1. **Let yourself feel bad.** You made an inadequate drawing? Allow yourself to feel bad about it. Wallow, beat yourself up, and hang your head—but only for a limited time. Yep, give yourself a pity deadline. After a half-hour, cut it out. It's time to . . .

2. **Find the good.** Look at that wretched drawing. Is the entire thing a flop? Or is there some little kernel of good in there? Maybe you shaded one small detail well. Or had a good concept even though the execution was poor. Give yourself credit for what went well, and carry that with you as you . . .

3. **Move on to the next piece.** Thankfully, there's always another blank page. Don't wait too long to get back to drawing after you've "struck out." You want to be able to . . .

4. **Own it, not become it.** In the famous words of Zig Ziglar, "Failure is an event, not a person." Having a failure and being a failure are two different things. You had a

88

failure, and you admitted this when you let yourself feel bad. Don't adopt failure as your identity. It's just a thing you did, not who you are. Revisit old drawings that you're proud of if you need to balance the scales. After all, you want to . . .

5. **Put your opinion first.** According to Brené Brown's research, perfectionism is about other people's perceptions, which is something that you can't control. Brown suggests that a way to take back the reins of your creative work is to stop asking, "But what will people think?" and to start asking, "But what do I think?"

So, what *do* you think? Can you ruin the page?

DAY 1

MOOD/ENERGY LEVEL: TIME OF DAY:

DAY 2

MOOD/ENERGY LEVEL: TIME OF DAY:

DAY 3

MOOD/ENERGY LEVEL: TIME OF DAY:

DAY 4

MOOD/ENERGY LEVEL: TIME OF DAY:

DAY 5

MOOD/ENERGY LEVEL: TIME OF DAY:

DAY 6

MOOD/ENERGY LEVEL: TIME OF DAY:

DAY 7

MOOD/ENERGY LEVEL: TIME OF DAY:

DAY 8

MOOD/ENERGY LEVEL: TIME OF DAY:

DAY 9

MOOD/ENERGY LEVEL: TIME OF DAY:

DAY 10

MOOD/ENERGY LEVEL: TIME OF DAY:

DAY 11

MOOD/ENERGY LEVEL: TIME OF DAY:

CHAPTER FIVE

BOX iT UP

Have you ever been to an improvisation (improv) comedy show? Or watched *Whose Line Is It Anyway* on television? The players work together as a team to perform comedic scenes on the spot, with no rehearsal. Of course, this setup has the potential to go very badly; that's part of what makes it fun to watch—it's risky. But a good team can create transcendently funny stories together, and part of that is because all of the players follow the same guidelines.

The guidelines are usually explained to the audience before each scene (ie, it's the first day of a new job, for example), and some of the enjoyment for the audience comes from watching the actors play within the sandbox they've established for themselves (none of the actors in the scene are allowed to smile). Even more exciting is when they flirt with breaking the rules (covering their mouth to hide a smile that might have escaped), and the audience knows the players are being "bad" and stepping out of bounds.

Imagine putting four genuinely funny people on stage together with the instructions to be "funny." That might not go so well; the instructions are so open-ended that the actors wouldn't know where to start, and they might come up with four different ideas of how they should be funny together. By having guidelines, the players are able to work together more easily. The boundaries actually make it easier to create.

The same applies to you. As an artist, it will be easier for you to create if you have some guidelines in place. This might sound like the opposite of artistic freedom and expressiveness, but like the improv players, you'll find that restrictions can actually set you free to do your best work.

THINK INSIDE THE BOX

If you have ever thought, "I have no idea what to draw" or "I have too many ideas and don't know which one to pick" or "All of my ideas sound bad," then try this: box it up.

Instead of having free rein to draw anything under the sun, narrow your focus and only draw things that fall within the box you establish.

Here are some examples of artists who have done "box" projects:

Lisa Sonora was looking for a creative challenge to get back into art-making. Inspired by marathon runners, she wanted a marathon-style project to commit to. She decided on a project that felt as intimidating as a marathon to her: making 1,008 small paintings. Each

piece was the same size, made with the same materials, and featured the same silhouette—that was the "box" she gave herself. The creative challenge was to make each piece unique and special. Lisa had given herself a box to work within, and when she sat down to create, she knew she'd be working toward her goal of 1,008 paintings.

Andy Warhol became one of the world's most well known pop artists with the help of 32 cans of soup. In 1962, in what has been called a watershed event in the art world, he exhibited 32 almost identical paintings of every variety of Campbell's soup. He went on to create many more "box" projects where a collection was comprised of slight variations of one image, including the Coca-Cola bottle, the dollar bill, and a portrait of Marilyn Monroe. This kind of repetition became one of the calling cards of his work, and helped cement him as the highest-priced American artist of his time.

THE DIY BOX

Now it's time for you to experiment with your own box project. You can be inspired by the artists above, or take a different tack. If you're not sure where to start, here are some box projects to consider:

- Choose one subject or shape to be the "star," and draw many variations of that one thing.

- Draw the same event or subject over time, with each drawing acting as a snapshot of a different day.

- Imagine that you're preparing for your own gallery show. Choose an actual wall or space you want to fill, even if it's just the front of your refrigerator. Having to work with a space will influence the size and number of drawings you do.

- Choose one of your favorite albums, and do a drawing for each song.

- Draw a famous work of art from a different perspective. What would Edvard Munch's *The Scream* look like from the vantage point of the screamer?

- Randomly choose a word from a dictionary or a book on your bookshelf and do a series of drawings based on that word.

- Watch a live performance of theater or dance, and create drawings based on memorable moments or emotions you experienced from the show.

- Join an online drawing challenge. There are many sketchbook projects and thirty day drawing challenges to participate in. Or create your own!

No matter what you decide to do, make a commitment to your box project now so that the next time you sit down to draw, you'll have a goal to work toward.

Not everything you draw needs to happen within a framework. Having time to wander, explore, and work without an agenda is vital for an artist. But when you're feeling scattered, give yourself a box and enjoy the freedom—and rewards—of working within constraints.

DAY 1

MOOD/ENERGY LEVEL: TIME OF DAY:

DAY 2

MOOD/ENERGY LEVEL: TIME OF DAY:

DAY 3

MOOD/ENERGY LEVEL: TIME OF DAY:

DAY 4

MOOD/ENERGY LEVEL: TIME OF DAY:

DAY 5

MOOD/ENERGY LEVEL: TIME OF DAY:

DAY 6

MOOD/ENERGY LEVEL: TIME OF DAY:

DAY 7

MOOD/ENERGY LEVEL: TIME OF DAY:

DAY 8

MOOD/ENERGY LEVEL: TIME OF DAY:

DAY 9

MOOD/ENERGY LEVEL: TIME OF DAY:

DAY 10

MOOD/ENERGY LEVEL: TIME OF DAY:

DAY 11

MOOD/ENERGY LEVEL: TIME OF DAY:

CHAPTER SIX

FIND YOUR TRIBE

Drawing can be a wonderful retreat. When it's just you, your sketchbook, and a pen, you might withdraw into your own little world, enter an almost meditative state, and then wonder where the time went; emerging energized and satisfied with what you created. Or you may become hyperfocused and tense up as you get things just so. Either way, it's just you. But if you don't consciously seek out connection with others, you can feel isolated, and your art can suffer.

Luckily, the antidote is simple: finding a tribe or community to share your art with can improve your work, make you feel better, and help ensure that you never quit drawing.

DARE TO BARE

If you have been hesitant to share your work with others, this advice might sound intimidating—or even downright horrifying! There's a reason sketchbooks have covers, right? All you need is the tiniest bit of openness to talk about your work and let supportive people see what you're up to. You don't need to rent out a billboard for the latest sketch of your coffee cup; you just need to crack the door to the closet you've been hiding in. (Ahhhhh, fresh air!)

There are five kinds of support networks available to you as an artist. It's good to have at least two, but it's perfectly fine to start with just one. And you know what? You may already have one. Let's take a look.

1. Your "No Matter What" Friends and Family

These are the people in your life who always have your back no matter what you're doing. It's not your art that they're particularly invested in; it's *you*. If you decided drawing was out and sword swallowing was in, they would be the first people to show up at your street performances. These people might be your parents, your spouse, a roommate, or a lifelong friend.

Your "no matter whats" will always be there for you, but they may not understand the nuances of your art or why it matters to you. That's why it's good to layer in another kind of support.

143

2. Colleagues

Your colleagues are peers who are in similar situation as you. Maybe they've been drawing for a longer or shorter period of time than you have, or maybe they work in an entirely different medium. Either way, your artistic goals and worldviews will overlap enough that you feel a kinship with them.

Twenty years ago, the psychologists Roy Baumeister and Mark Leary discovered that "belonging" is not just a human want, but a human need. We are driven to connect with each other and form bonds. In the absence of belonging, individual performance goes down and self-defeating behaviors go up. Furnish a sense of belonging, and the trends reverse.

You need a group of people where your crazy dream is the norm—where you're not an outsider, but a welcomed and valued member of a wee tribe.

3. Teachers

At some point in your artistic career, you'll want a teacher. There are many great books and video tutorials that can help you improve your drawing, but nothing can take the place of an experienced artist who can provide you with the crucial thing those books and videos cannot: feedback and instruction.

You can't improve on what you can't see, and if you are a beginner, you especially have limited vision. A seasoned teacher of the arts will be able to give you insights that will help you improve exponentially. If you've ever wanted a lightning-speed button for improving your drawing, a teacher could be just that.

Need more convincing that you should find a teacher? Psychologists Jagdeep Chhokar and Jerry Wallin discovered that workers who received feedback on their performance at least every two weeks devoted more time and effort to their tasks, and in turn improved at them. Get a teacher, get feedback, and get better at drawing.

4. Mentors

You might think that a mentor and a teacher are the same thing because some teachers *are* great mentors, but there are some important distinctions you should know about if you want to try out these different kinds of support.

A teacher is there to help you acquire a specific skill or to learn a process. A mentor is charged with helping a person develop as a whole artist. Sure, they might be able to help you with a specific technique you're struggling with of course, but a mentor is able to draw on their own successes and failures as an artist to encourage you, offer an experienced

144

perspective, model positive habits, guide you through your creative process, and help you apply skills and techniques to new situations and opportunities.

A good mentor can be hard to find. Unlike finding a teacher, there aren't many formal channels for matching up with a mentor, though you can check with the art department of your local university or community college for leads.

5. People You Inspire

Yep, you inspire someone! It could be a classmate who is interested in art but hasn't found the courage to go for it, your social media followers, or your younger cousin. You inspire someone, and hearing from him or her is important.

The people who you inspire see things in you and about you that you are unable to see, and having that reflected back to you is very powerful. Connecting with these folks can help build your confidence and cement you as an artist—and a leader—in your own mind. Oh yeah, artists are leaders. Didn't you know?

Kerby Rosanes, master of doodles and illustrator of this sketchbook, has over a million fans all over the world on Facebook, and he regularly shares his artwork via his blog *Sketchy Stories*. Kerby inspires his fans by sharing his art and tidbits about his creative process. Begin with who you have, share your work, and enjoy connecting with others over your art.

Are you convinced that you should come out of your drawing cave? Enjoying a solo art career doesn't mean doing it alone. There are many forms of support available, and you can have fun deciding which combinations you'd like to try. When you build your tribe, you give yourself the opportunity to improve as an artist, have more fun, and give back to others.

Artist, student, leader, tribe builder: that's you!

DAY 1

MOOD/ENERGY LEVEL: TIME OF DAY:

DAY 2

MOOD/ENERGY LEVEL: TIME OF DAY:

DAY 3

MOOD/ENERGY LEVEL: TIME OF DAY:

DAY 4

MOOD/ENERGY LEVEL: TIME OF DAY:

DAY 5

MOOD/ENERGY LEVEL: TIME OF DAY:

DAY 6

MOOD/ENERGY LEVEL: TIME OF DAY:

DAY 7

MOOD/ENERGY LEVEL: TIME OF DAY:

DAY 8

MOOD/ENERGY LEVEL: TIME OF DAY:

DAY 9

MOOD/ENERGY LEVEL: TIME OF DAY:

DAY 10

MOOD/ENERGY LEVEL: TIME OF DAY:

DAY 11

MOOD/ENERGY LEVEL: TIME OF DAY:

FURTHER READING

The Power of Habit by Charles Duhigg

The Creative Habit by Twyla Tharp

How to Fly a Horse by Kevin Ashton

The Procrastination Equation by Piers Steel

The Gifts of Imperfection by Brené Brown

The Artist's Way by Julia Cameron

Truth in Comedy by Charna Halpern and Del Close